SHOW YOUR WORK!

10 WAYS TO SHARE YOUR CREATIVITY AND GET DISCOVERED

AUSTIN KLEON

WORKMAN PUBLISHING COMPANY · NEW YORK

Library of Congress Cataloging-in-Publication Data

Kleon, Austin.

Show your work! : 10 ways to share your creativity and get discovered / by Austin Kleon.

 pages cm

 ISBN 978-0-7611-7897-2 (alk. paper)

1. Career development. 2. Success in business. 3. Business networks.

I. Title.

 HF5381.K5854 2014

 650.1--dc23 2013046696

Workman books are available at special discounts when purchased in bulk for premiums and sales promotions as well as for fund-raising or educational use. Special editions or book excerpts can also be created to specification. For details, contact the Special Sales Director at the address below, or send an email to specialmarkets@workman.com.

Workman Publishing Co., Inc.

225 Varick Street

New York, NY 10014-4381

workman.com

WORKMAN is a registered trademark of Workman Publishing Co., Inc.

Printed in China on responsibly sourced paper

First printing April 2014

15

FOR MEGHAN

"FOR ARTISTS
PROBLEM TO SO

GET ONESELF

— HONORÉ

THE GREAT

E IS HOW TO

IOTICED."

DE BALZAC

"Creativity is not a talent.
It is a way of operating."

—*John Cleese*

A NEW WAY OF OPERATING

When I have the privilege of talking to my readers, the most common questions they ask me are about self-promotion. *How do I get my stuff out there? How do I get noticed? How do I find an audience? How did you do it?*

I *hate* talking about self-promotion. Comedian Steve Martin famously dodges these questions with the advice, "Be so good they can't ignore you." If you just focus on getting really good, Martin says, people will come to you. I happen to agree: You don't really find an audience for your work; they find you. But it's not enough to be good.

In order to be found, you have to *be findable*. I think there's an easy way of putting your work out there and making it discoverable *while* you're focused on getting really good at what you do.

Almost all of the people I look up to and try to steal from today, regardless of their profession, have built *sharing* into their routine. These people aren't schmoozing at cocktail parties; they're too busy for that. They're cranking away in their studios, their laboratories, or their cubicles, but instead of maintaining absolute secrecy and hoarding their work, they're open about what they're working on, and they're consistently posting bits and pieces of their work, their ideas, and what they're learning online. Instead of wasting their time "networking," they're taking advantage of the network. By generously sharing their ideas and their knowledge, they often gain an audience that they can then leverage when they need it—for fellowship, feedback, or patronage.

I wanted to create a kind of beginner's manual for this way of operating, so here's what I came up with: a book for people who hate the very idea of self-promotion. An *alternative*, if you will, to self-promotion. I'm going to try to teach you how to think about your work as a never-ending process, how to share your process in a way that attracts people who might be interested in what you do, and how to deal with the ups and downs of putting yourself and your work out in the world. If *Steal Like an Artist* was a book about stealing influence from other people, this book is about how to influence others by letting them steal from *you*.

Imagine if your next boss didn't have to read your résumé because he already reads your blog. Imagine being a student and getting your first gig based on a school project you posted online. Imagine losing your job but having a social network of people familiar with your work and ready to help you find a new one. Imagine turning a side project or

crafting something

is a long,
uncertain process.

a

maker should

show

her

work

a hobby into your profession because you had a following that could support you.

Or imagine something simpler and just as satisfying: spending the majority of your time, energy, and attention practicing a craft, learning a trade, or running a business, while also allowing for the possibility that your work might attract a group of people who share your interests.

All you have to do is *show your work*.

N'T HAVE

GENIUS.

FIND A SCENIUS.

> "Give what you have.
> To someone, it may be better
> than you dare to think."
>
> —Henry Wadsworth Longfellow

There are a lot of destructive myths about creativity, but one of the most dangerous is the "lone genius" myth: An individual with superhuman talents appears out of nowhere at certain points in history, free of influences or precedent, with a direct connection to God or The Muse. When inspiration comes, it strikes like a lightning bolt, a lightbulb switches on in his head, and then he spends the rest of his time toiling away in his studio, shaping this idea into a finished masterpiece that he releases into the world to great fanfare. If you believe in the lone genius myth, creativity is an *antisocial* act, performed by only a few great figures—mostly dead men with names like Mozart, Einstein, or Picasso. The rest of us are left to stand around and gawk in awe at their achievements.

There's a healthier way of thinking about creativity that the musician Brian Eno refers to as "scenius." Under this model, great ideas are often birthed by a group of creative individuals—artists, curators, thinkers, theorists, and other

tastemakers—who make up an "ecology of talent." If you look back closely at history, many of the people who we think of as lone geniuses were actually part of "a whole scene of people who were supporting each other, looking at each other's work, copying from each other, stealing ideas, and contributing ideas." Scenius doesn't take away from the achievements of those great individuals; it just acknowledges that good work isn't created in a vacuum, and that creativity is always, in some sense, a collaboration, the result of a mind connected to other minds.

What I love about the idea of scenius is that it makes room in the story of creativity for the rest of us: the people who don't consider ourselves geniuses. Being a valuable part of a scenius is not necessarily about how smart or talented you are, but about what you have to contribute—the ideas you share, the quality of the connections you make, and the conversations you start. If we forget about genius and think more about how we can nurture and contribute to a scenius,

we can adjust our own expectations and the expectations of the worlds we want to accept us. We can stop asking what others can do for us, and start asking what we can do for others.

We live in an age where it's easier than ever to join a scenius. The Internet is basically a bunch of sceniuses connected together, divorced from physical geography. Blogs, social media sites, email groups, discussion boards, forums—they're all the same thing: virtual scenes where people go to hang out and talk about the things they care about. There's no bouncer, no gatekeeper, and no barrier to entering these scenes: You don't have to be rich, you don't have to be famous, and you don't have to have a fancy résumé or a degree from an expensive school. Online, everyone—the artist and the curator, the master and the apprentice, the expert and the amateur—has the ability to contribute something.

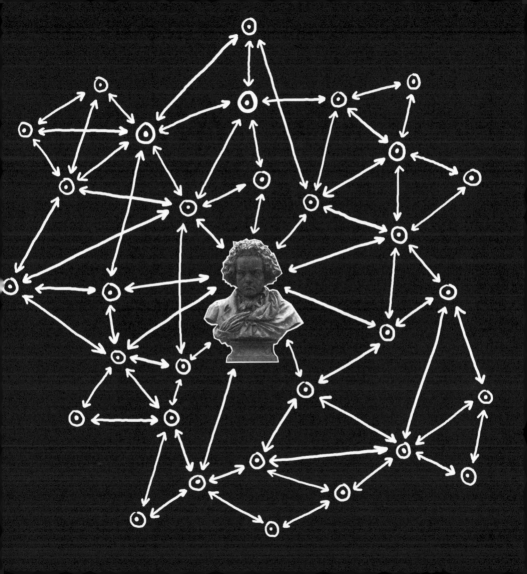

BE AN AMATEUR.

"That's all any of us are:
amateurs. We don't live long
enough to be anything else."

—Charlie Chaplin

We're all terrified of being revealed as amateurs, but in fact, today it is the *amateur*—the enthusiast who pursues her work in the spirit of love (in French, the word means "lover"), regardless of the potential for fame, money, or career—who often has the advantage over the professional. Because they have little to lose, amateurs are willing to try anything and share the results. They take chances, experiment, and follow their whims. Sometimes, in the process of doing things in an unprofessional way, they make new discoveries. "In the beginner's mind, there are many possibilities," said Zen monk Shunryu Suzuki. "In the expert's mind, there are few."

Amateurs are not afraid to make mistakes or look ridiculous in public. They're in love, so they don't hesitate to do work that others think of as silly or just plain stupid. "The stupidest possible creative act is still a creative act," writes Clay Shirky in his book *Cognitive Surplus*. "On the spectrum of creative work, the difference between the

mediocre and the good is vast. Mediocrity is, however, still on the spectrum; you can move from mediocre to good in increments. The real gap is between doing nothing and doing something." Amateurs know that contributing something is better than contributing nothing.

Amateurs might lack formal training, but they're all lifelong learners, and they make a point of learning in the open, so that others can learn from their failures and successes. Writer David Foster Wallace said that he thought good nonfiction was a chance to "watch somebody reasonably bright but also reasonably average pay far closer attention and think at far more length about all sorts of different stuff than most of us have a chance to in our daily lives." Amateurs fit the same bill: They're just regular people who get obsessed by something and spend a ton of time thinking out loud about it.

Sometimes, amateurs have more to teach us than experts. "It often happens that two schoolboys can solve difficulties in their work for one another better than the master can," wrote

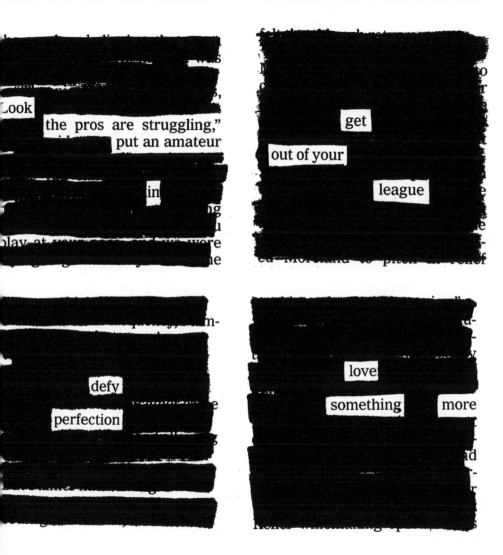

Look the pros are struggling," put an amateur in

get out of your league

defy perfection

love something more

author C. S. Lewis. "The fellow-pupil can help more than the master because he knows less. The difficulty we want him to explain is one he has recently met. The expert met it so long ago he has forgotten." Watching amateurs at work can also inspire us to attempt the work ourselves. "I saw the Sex Pistols," said New Order frontman Bernard Sumner. "They were terrible. . . . I wanted to get up and be terrible with them." Raw enthusiasm is contagious.

The world is changing at such a rapid rate that it's turning us *all* into amateurs. Even for professionals, the best way to flourish is to retain an amateur's spirit and embrace uncertainty and the unknown. When Radiohead frontman Thom Yorke was asked what he thought his greatest strength was, he answered, "That I don't know what I'm doing." Like one of his heroes, Tom Waits, whenever Yorke feels like his songwriting is getting too comfortable or stale, he'll pick up an instrument he doesn't know how to play and try to write with it. This is yet another trait of

amateurs—they'll use whatever tools they can get their hands on to try to get their ideas into the world. "I'm an artist, man," said John Lennon. "Give me a tuba, and I'll get you something out of it."

The best way to get started on the path to sharing your work is to think about what you want to learn, and make a commitment to learning it in front of others. Find a scenius, pay attention to what others are sharing, and then start taking note of what they're *not* sharing. Be on the lookout for voids that you can fill with your own efforts, no matter how bad they are at first. Don't worry, for now, about how you'll make money or a career off it. Forget about being an expert or a professional, and wear your amateurism (your heart, your love) on your sleeve. Share what you love, and the people who love the same things will find you.

You can't find your voice if you don't use it.

"Find your voice, shout it from the rooftops, and keep doing it until the people that are looking for you find you."

— *Dan Harmon*

We're always being told *find your voice*. When I was younger, I never really knew what this meant. I used to worry a lot about voice, wondering if I had my own. But now I realize that the only way to find your voice is to use it. It's hardwired, built into you. Talk about the things you love. Your voice will follow.

When the late film critic Roger Ebert went through several intense surgeries to treat his cancer, he lost the ability to speak. He lost his voice—physically and permanently. Here was a man who made a great deal of his living by speaking on television and now he couldn't say a word. In order to communicate with his friends and family, he'd have to either scribble responses on a pad of paper, or type on his Mac and have the awkward computer voice read it out loud through his laptop speakers.

Cut off from everyday conversation, he poured himself into tweeting, posting to Facebook, and blogging at rogerebert .com. He ripped out posts at a breakneck speed, writing

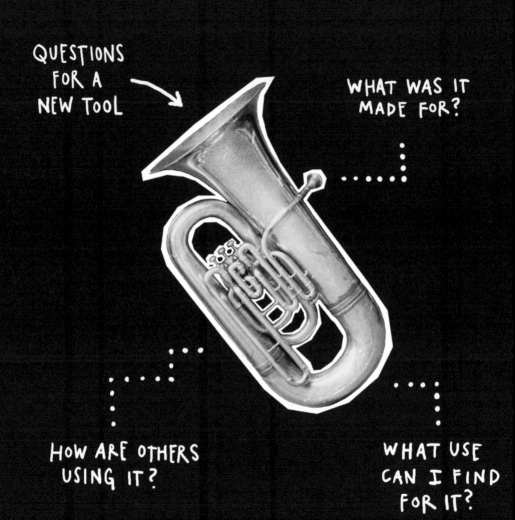

thousands and thousands of words about everything he could think of—his boyhood in Urbana, Illinois, his love for Steak 'n Shake, his conversations with famous movie actors, his thoughts on his inevitable death. Hundreds and hundreds of people would respond to his posts, and he would respond back. Blogging became his primary way of communicating with the world. "On the web, my real voice finds expression," he wrote.

Ebert knew his time on this planet was short, and he wanted to share everything he could in the time he had left. "Mr. Ebert writes as if it were a matter of life and death," wrote journalist Janet Maslin, "because it is." Ebert was blogging because he had to blog—because it was a matter of being heard, or not being heard. A matter of existing or not existing.

It sounds a little extreme, but in this day and age, if your work isn't online, it doesn't exist. We all have the opportunity to use our voices, to have our say, but so many of us are wasting it. If you want people to know about what you do and the things you care about, you have to share.

"Remembering that I'll be dead soon is the most important tool I've ever encountered to help me make the big choices in life. Because almost everything—all external expectations, all pride, all fear of embarrassment or failure—these things just fall away in the face of death, leaving only what is truly important. Remembering that you are going to die is the best way I know to avoid the trap of thinking you have something to lose. You are already naked."

—*Steve Jobs*

READ OBITUARIES.

If all this sounds scary or like a lot of work, consider this: One day you'll be dead. Most of us prefer to ignore this most basic fact of life, but thinking about our inevitable end has a way of putting everything into perspective.

We've all read stories of near-death experiences changing people's lives. When George Lucas was a teenager, he almost died in a car accident. He decided "every day now is an extra day," dedicated himself to film, and went on to direct *Star Wars*. Wayne Coyne, lead singer of The Flaming

Lips, was 16 when he was held up while working at a Long John Silver's. "I realized I was going to die," he says. "And when that gets into your mind . . . it utterly changed me . . . I thought, *I'm not going to sit here and wait for things to happen, I'm going to make them happen, and if people think I'm an idiot I don't care.*"

Tim Kreider, in his book *We Learn Nothing*, says that getting stabbed in the throat was the best thing to ever happen to him. For a whole year, he was happy and life was good. "You'd like to think that nearly getting killed would be a permanently life-altering experience," Kreider writes, but "the illumination didn't last." Eventually, he was back to "the busywork of living." The writer George Saunders, speaking of his own near-death experience, said, "For three or four days after that, it was the most beautiful world. To have gotten back in it, you know? And I thought, *if you could walk around like that all the time, to really have that awareness that it's actually going to end. That's the trick.*"

Unfortunately, I am a coward. As much as I would like the existential euphoria that comes with it, I don't really *want* a near-death experience. I want to stay safe and stay away from death as much as I can. I certainly don't want to taunt it or court it or invite it any closer than it needs to be. But I do somehow want to remember that it's coming for me.

It's for this reason that I read the obituaries every morning. Obituaries are like near-death experiences for cowards. Reading them is a way for me to think about death while also keeping it at arm's length.

Obituaries aren't really about death; they're about life. "The sum of every obituary is how heroic people are, and how noble," writes artist Maira Kalman. Reading about people who are dead now and did things with their lives makes me want to get up and do something decent with mine. Thinking about death every morning makes me want to live.

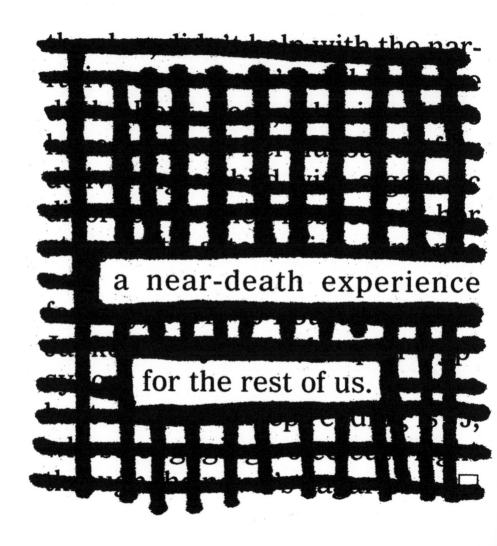

a near-death experience

for the rest of us.

Try it: Start reading the obituaries every morning. Take inspiration from the people who muddled through life before you—they all started out as amateurs, and they got where they were going by making do with what they were given, and having the guts to put themselves out there. Follow their example.

② THINK

NOT

PROCESS,

PRODUCT.

> "Pull back the curtain
> on your process."
>
> —Ann Friedman

TAKE PEOPLE BEHIND THE SCENES.

When a painter talks about her "work," she could be talking about two different things: There's the *artwork*, the finished piece, framed and hung on a gallery wall, and there's the *art work*, all the day-to-day stuff that goes on behind the scenes in her studio: looking for inspiration, getting an idea, applying oil to a canvas, etc. There's "painting," the noun, and there's "painting," the verb. As in all kinds of work, there is a distinction between the painter's *process*, and the *products* of her process.

Traditionally, the artist has been trained to regard her creative process as something that should be kept to herself. This way of thinking is articulated by David Bayles and

The

work is

all

that's

happened
in the day.

It is a process,

not

a

thing

Ted Orland in their book, *Art and Fear*: "To all viewers but yourself, what matters is the product: the finished artwork. To you, and you alone, what matters is the process: the experience of shaping the artwork." An artist is supposed to toil in secrecy, keeping her ideas and her work under lock and key, waiting until she has a magnificent product to show for herself before she tries to connect with an audience. "The private details of artmaking are utterly uninteresting to audiences," write Bayles and Orland, "because they're almost never visible—or even knowable—from examining the finished work."

This all made sense in a pre-digital age, when the only way an artist could connect with an audience was through a gallery show or write-up in some fancy art magazine. But today, by taking advantage of the Internet and social media, an artist can share whatever she wants, whenever she wants, at almost no cost. She can decide exactly how much or how little of her work and herself she will share, and she

can be as open about her process as she wants to—she can share her sketches and works-in-progress, post pictures of her studio, or blog about her influences, inspiration, and tools. By sharing her day-to-day process—the thing she really cares about—she can form a unique bond with her audience.

To many artists, particularly those who grew up in the pre-digital era, this kind of openness and the potential vulnerability that goes along with sharing one's process is a terrifying idea. Here's the author Edgar Allan Poe, writing in 1846: "Most writers—poets in especial—prefer having it understood that they compose by a species of fine frenzy— an ecstatic intuition—and would positively shudder at letting the public take a peep behind the scenes."

But human beings are interested in other human beings and what other human beings do. "People really do want to see how the sausage gets made." That's how designers Dan Provost and Tom Gerhardt put it in their book on

PROCESS
IS
MESSY.

entrepreneurship, *It Will Be Exhilarating*. "By putting things out there, consistently, you can form a relationship with your customers. It allows them to see the person behind the products." Audiences not only want to stumble across great work, but they, too, long to be creative and part of the creative process. By letting go of our egos and sharing our process, we allow for the possibility of people having an ongoing connection with us and our work, which helps us move more of our product.

"In order for connection to happen, we have to allow ourselves to be seen— really seen."

—Brené Brown

BECOME A DOCUMENTARIAN OF WHAT YOU DO.

In 2013, the Internet fell in love with astronaut Chris Hadfield, commander of the International Space Station. Three years earlier, Hadfield and his family were sitting around the dinner table, trying to figure out ways to generate interest for the Canadian Space Agency, which, like many space programs, faced major budget cuts and needed more public support. "Dad wanted a way to help people connect with the real side of what an astronaut's life is," said Hadfield's son Evan. "Not just the glamour and science, but also the day-to-day activities."

Commander Hadfield wanted to show his work.

Things fell into place when his sons explained social media to him and got him set up on Twitter and other social networks. During his next five-month mission, while performing all his regular astronautical duties, he tweeted, answered questions from his followers, posted pictures he'd taken of Earth, recorded music, and filmed YouTube videos of himself clipping his nails, brushing his teeth, sleeping, and even performing maintenance on the space station. Millions of people ate it all up, including my agent, Ted, who tweeted, "Wouldn't normally watch live video of a couple of guys doing plumbing repair, but IT'S IN SPACE!"

Now, let's face it: We're not all artists or astronauts. A lot of us go about our work and feel like we have nothing to show for it at the end of the day. But whatever the nature of your work, there is an art to what you do, and there are people who would be interested in that art, if only you presented it

to them in the right way. In fact, sharing your process might actually be most valuable if the products of your work aren't easily shared, if you're still in the apprentice stage of your work, if you can't just slap up a portfolio and call it a day, or if your process doesn't necessarily lead to tangible finished products.

How can you show your work even when you have nothing to show? The first step is to scoop up the scraps and the residue of your process and shape them into some interesting bit of media that you can share. You have to turn the invisible into something other people can see. "You have to make stuff," said journalist David Carr when he was asked if he had any advice for students. "No one is going to give a damn about your résumé; they want to see what you have made with your own little fingers."

Become a documentarian of what you do. Start a work journal: Write your thoughts down in a notebook, or speak them into an audio recorder. Keep a scrapbook.

RESEARCH	JOURNALS
REFERENCE	DRAFTS
DRAWINGS	PROTOTYPES
PLANS ~~PEOPLE~~	DEMOS
SKETCHES	DIAGRAMS
INTERVIEWS	NOTES
AUDIO	INSPIRATION
PHOTOGRAPHS	& SCRAPBOOK.
VIDEO	STORIES
PINBOARDS	COLLECTIONS

Take a lot of photographs of your work at different stages in your process. Shoot video of you working. This isn't about making art, it's about simply keeping track of what's going on around you. Take advantage of all the cheap, easy tools at your disposal—these days, most of us carry a fully functional multimedia studio around in our smartphones.

Whether you share it or not, documenting and recording your process as you go along has its own rewards: You'll start to see the work you're doing more clearly and feel like you're making progress. And when you're ready to share, you'll have a surplus of material to choose from.

③ SHARE

SMALL EV

SOMETHING

...ERY DAY.

"Put yourself, and your work, out there every day, and you'll start meeting some amazing people."

—*Bobby Solomon*

SEND OUT A DAILY DISPATCH.

Overnight success is a myth. Dig into almost every overnight success story and you'll find about a decade's worth of hard work and perseverance. Building a substantial body of work takes a long time—a lifetime, really—but thankfully, you don't need that time all in one big chunk. So forget about decades, forget about years, and forget about months. Focus on days.

The day is the only unit of time that I can really get my head around. Seasons change, weeks are completely human-made, but the day has a rhythm. The sun goes up; the sun goes down. I can handle that.

Once a day, after you've done your day's work, go back to your documentation and find one little piece of your process that you can share. Where you are in your process will determine what that piece is. If you're in the very early stages, share your influences and what's inspiring you. If you're in the middle of executing a project, write about your methods or share works in progress. If you've just completed a project, show the final product, share scraps from the cutting-room floor, or write about what you learned. If you have lots of projects out into the world, you can report on how they're doing—you can tell stories about how people are interacting with your work.

A daily dispatch is even better than a résumé or a portfolio, because it shows what we're working on *right now*. When the artist Ze Frank was interviewing job candidates, he complained, "When I ask them to show me work, they show me things from school, or from another job, but I'm more interested in what they did last weekend." A good

ONE YEAR

↓

× × × × ×
× × × × × × × × × × × × × × × × × × ×
× × × × × × × × × × × × × × × × × × × ×
× × × × × × × × × × × × × × × × × × × ×
× × × × × × × × × × × × × × × × × × × ×
× × × × × × × × × × × × × × × × × × × ×
× × × × × × × × × × × × × × × × × × × ×
× × × × × × × × × × × × × × × × × × × ×
× × × × × × × × × × × × × × × × × × × ×
× × × × × × × × × × × × × × × × × × × ×
× × × × × × × × × × × × × × × × × × × ×
× × × × × × × × × × × × × × × × × × × ×
× × × × × × × × × × × × × × × × × × × ×
× × × × × × × × × × × × × × × × × × × ×
× × × × × × × × × × × × × × × × × × × ×
× × × × × × × × × × × × × × × × × × × ×
× × × × × × × × × × × × × × × × × × × ×
× × × × × × × × × × × × × × × × × × × ×
× × × × × × × × × × × × × × × × × × × ×

daily dispatch is like getting all the DVD extras before a movie comes out—you get to watch deleted scenes and listen to director's commentary *while* the movie is being made.

The form of what you share doesn't matter. Your daily dispatch can be anything you want—a blog post, an email, a tweet, a YouTube video, or some other little bit of media. There's no one-size-fits-all plan for everybody.

Social media sites are the perfect place to share daily updates. Don't worry about being on every platform; pick and choose based on what you do and the people you're trying to reach. Filmmakers hang out on YouTube or Vimeo. Businesspeople, for some strange reason, love LinkedIn. Writers love Twitter. Visual artists tend to like Tumblr, Instagram, or Facebook. The landscape is constantly changing, and new platforms are always popping up . . . and disappearing.

Don't be afraid to be an early adopter—jump on a new platform and see if there's something interesting you can do with it. If you can't find a good use for a platform, feel free to abandon it. Use your creativity. Film critic Tommy Edison, who's been blind since birth, takes photos of his day-to-day life and posts them to Instagram under @blindfilmcritic. He's followed by more than 30,000 people!

A lot of social media is just about typing into boxes. What you type into the box often depends on the prompt. Facebook asks you to indulge yourself, with questions like "How are you feeling?" or "What's on your mind?" Twitter's is hardly better: "What's happening?" I like the tagline at dribbble.com: "What are you working on?" Stick to that question and you'll be good. Don't show your lunch or your latte; show your work.

Don't worry about everything you post being perfect. Science fiction writer Theodore Sturgeon once said that

90 percent of everything is crap. The same is true of our own work. The trouble is, we don't always know what's good and what sucks. That's why it's important to get things in front of others and see how they react. "Sometimes you don't always know what you've got," says artist Wayne White. "It really does need a little social chemistry to make it show itself to you sometimes."

Don't say you don't have enough time. We're all busy, but we all get 24 hours a day. People often ask me, "How do you find the time for all this?" And I answer, "I look for it." You find time the same place you find spare change: in the nooks and crannies. You find it in the cracks between the big stuff—your commute, your lunch break, the few hours after your kids go to bed. You might have to miss an episode of your favorite TV show, you might have to miss an hour of sleep, but you can find the time if you look for it. I like to work while the world is sleeping, and share while the world is at work.

Of course, don't let sharing your work take precedence over actually doing your work. If you're having a hard time balancing the two, just set a timer for 30 minutes. Once the timer goes off, kick yourself off the Internet and get back to work.

"One day at a time. It sounds so simple. It actually is simple but it isn't easy: It requires incredible support and fastidious structuring."

—Russell Brand

THE "SO WHAT?" TEST

> "Make no mistake: This is not your diary. You are not letting it all hang out. You are picking and choosing every single word."
>
> —*Dani Shapiro*

Always remember that anything you post to the Internet has now become public. "The Internet is a copy machine," writes author Kevin Kelly. "Once anything that can be copied is brought into contact with the Internet, it will be copied, and those copies never leave." Ideally, you *want* the work you post online to be copied and spread to every corner of the Internet, so don't post things online that you're not ready for everyone in the world to see. As publicist Lauren Cerand says, "Post as though everyone who can read it has the power to fire you."

Be open, share imperfect and unfinished work that you want feedback on, but don't share absolutely everything. There's a big, big difference between sharing and over-sharing.

The act of sharing is one of generosity—you're putting something out there because you think it might be helpful or entertaining to someone on the other side of the screen.

WHAT to SHOW:

~~DOGS~~ ~~SUNSETS~~

~~CATS~~ ~~LUNCHES~~

~~BABIES~~ ~~LATTES~~

~~SELFIES~~ (WORK)

I had a professor in college who returned our graded essays, walked up to the chalkboard, and wrote in huge letters: "SO WHAT?" She threw the piece of chalk down and said, "Ask yourself that every time you turn in a piece of writing." It's a lesson I never forgot.

Always be sure to run everything you share with others through The "So What?" Test. Don't overthink it; just go with your gut. If you're unsure about whether to share something, let it sit for 24 hours. Put it in a drawer and walk out the door. The next day, take it out and look at it with fresh eyes. Ask yourself, "Is this helpful? Is it entertaining? Is it something I'd be comfortable with my boss or my mother seeing?" There's nothing wrong with saving things for later. The SAVE AS DRAFT button is like a prophylactic—it might not feel as good in the moment, but you'll be glad you used it in the morning.

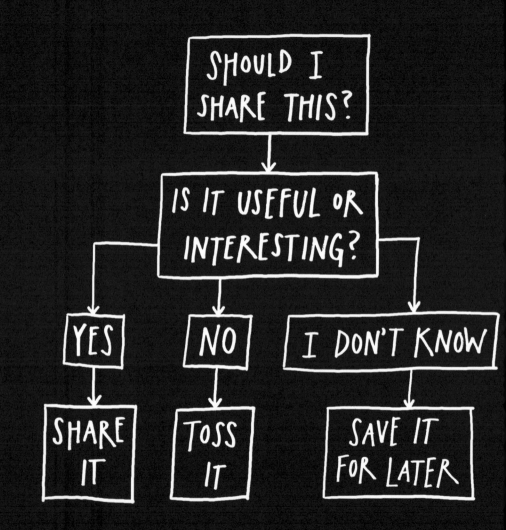

TURN YOUR FLOW INTO STOCK.

"If you work on something a little bit every day, you end up with something that is massive."

—Kenneth Goldsmith

"Stock and flow" is an economic concept that writer Robin Sloan has adapted into a metaphor for media: "Flow is the feed. It's the posts and the tweets. It's the stream of daily and sub-daily updates that remind people you exist. Stock is the durable stuff. It's the content you produce that's as interesting in two months (or two years) as it is today. It's what people discover via search. It's what spreads slowly but surely, building fans over time." Sloan says the magic formula is to maintain your flow while working on your stock in the background.

In my experience, your stock is best made by collecting, organizing, and expanding upon your flow. Social media sites function a lot like public notebooks—they're places where we think out loud, let other people think back at us, then hopefully think some more. But the thing about keeping notebooks is that you have to revisit them in order to make the most out of them. You have to flip back through old ideas to see what you've been thinking. Once

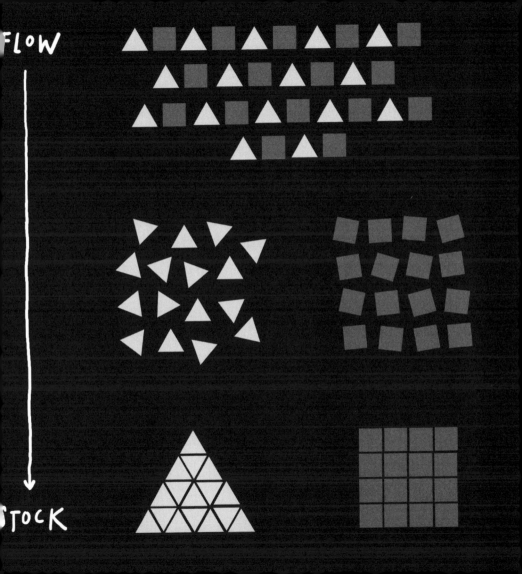

FLOW

STOCK

you make sharing part of your daily routine, you'll notice themes and trends emerging in what you share. You'll find patterns in your flow.

When you detect these patterns, you can start gathering these bits and pieces and turn them into something bigger and more substantial. You can turn your flow into stock. For example, a lot of the ideas in this book started out as tweets, which then became blog posts, which then became book chapters. Small things, over time, can get big.

BUILD A GOOD (DOMAIN) NAME.

"Carving out a space for yourself online, somewhere where you can express yourself and share your work, is still one of the best possible investments you can make with your time."

—Andy Baio

Social networks are great, but they come and go. (Remember Myspace? Friendster? GeoCities?) If you're really interested in sharing your work and expressing yourself, nothing beats owning your own space online, a place that you control, a place that no one can take away from you, a world headquarters where people can always find you.

More than 10 years ago, I staked my own little Internet claim and bought the domain name austinkleon.com. I was a complete amateur with no skills when I began building my website: It started off bare bones and ugly. Eventually, I figured out how to install a blog, and that changed everything. A blog is the ideal machine for turning flow into stock: One little blog post is nothing on its own, but publish a thousand blog posts over a decade, and it turns into your life's work. My blog has been my sketchbook, my studio, my gallery, my storefront, and my salon. Absolutely everything good that has happened in my career can be

traced back to my blog. My books, my art shows, my speaking gigs, some of my best friendships—they all exist because I have my own little piece of turf on the Internet.

So, if you get one thing out of this book make it this: Go register a domain name. Buy www.[insert your name here].com. If your name is common, or you don't like your name, come up with a pseudonym or an alias, and register that. Then buy some web hosting and build a website. (These things sound technical, but they're really not—a few Google searches and some books from the library will show you the way.) If you don't have the time or inclination to build your own site, there's a small army of web designers ready to help you. Your website doesn't have to look pretty; it just has to exist.

Don't think of your website as a self-promotion machine, think of it as a self-invention machine. Online, you can become the person you really want to be. Fill your website with your work and your ideas and the stuff you care about.

Over the years, you will be tempted to abandon it for the newest, shiniest social network. Don't give in. Don't let it fall into neglect. Think about it in the long term. Stick with it, maintain it, and let it change with you over time.

When she was young and starting out, Patti Smith got this advice from William Burroughs: "Build a good name. Keep your name clean. Don't make compromises. Don't worry about making a bunch of money or being successful. Be concerned with doing good work . . . and if you can build a good name, eventually that name will be its own currency."

The beauty of owning your own turf is that you can do whatever you want with it. Your domain name is your domain. You don't have to make compromises. Build a good domain name, keep it clean, and eventually it will be its own currency. Whether people show up or they don't, you're out there, doing your thing, ready whenever they are.

"The problem with hoarding is you end up living off your reserves. Eventually, you'll become stale. If you give away everything you have, you are left with nothing. This forces you to look, to be aware, to replenish. . . . Somehow the more you give away, the more comes back to you."

—Paul Arden

DON'T BE A HOARDER.

If you happened to be wealthy and educated and alive in 16th- and 17th-century Europe, it was fashionable to have a *Wunderkammern*, a "wonder chamber," or a "cabinet of curiosities" in your house—a room filled with rare and remarkable objects that served as a kind of external display of your thirst for knowledge of the world. Inside a cabinet of curiosities you might find books, skeletons, jewels, shells, art, plants, minerals, taxidermy specimens, stones, or any other exotic artifact. These collections often juxtaposed

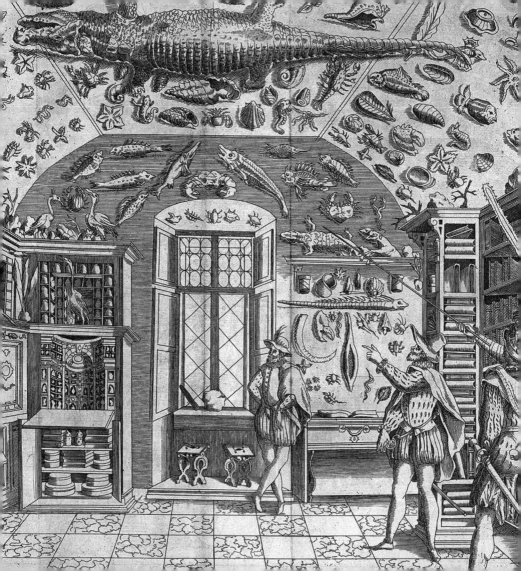

both natural and human-made marvels, revealing a kind of mash-up of handiwork by both God and human beings. They were the precursors to what we think of today as the modern museum—a place dedicated to the study of history, nature, and the arts.

We all have our own treasured collections. They can be physical cabinets of curiosities, say, living room bookshelves full of our favorite novels, records, and movies, or they can be more like intangible museums of the heart, our skulls lined with memories of places we've been, people we've met, experiences we've accumulated. We all carry around the weird and wonderful things we've come across while doing our work and living our lives. These mental scrapbooks form our tastes, and our tastes influence our work.

There's not as big of a difference between collecting and creating as you might think. A lot of the writers I know see the act of reading and the act of writing as existing on opposite ends of the same spectrum: The reading feeds the

writing, which feeds the reading. "I'm basically a curator," says the writer and former bookseller Jonathan Lethem. "Making books has always felt very connected to my bookselling experience, that of wanting to draw people's attention to things that I liked, to shape things that I liked into new shapes."

Our tastes make us what we are, but they can also cast a shadow over our own work. "All of us who do creative work, we get into it because we have good taste," says public radio personality Ira Glass. "But there is this gap. For the first couple years you make stuff, it's just not that good. It's trying to be good, it has potential, but it's not. But your taste, the thing that got you into the game, is still killer." Before we're ready to take the leap of sharing our own work with the world, we can share our tastes in the work of others.

Where do you get your inspiration? What sorts of things do you fill your head with? What do you read? Do you

subscribe to anything? What sites do you visit on the Internet? What music do you listen to? What movies do you see? Do you look at art? What do you collect? What's inside your scrapbook? What do you pin to the corkboard above your desk? What do you stick on your refrigerator? Who's done work that you admire? Who do you steal ideas from? Do you have any heroes? Who do you follow online? Who are the practitioners you look up to in your field?

Your influences are all worth sharing because they clue people in to who you are and what you do—sometimes even more than your own work.

"You're only as good as your record collection."

—DJ Spooky

NO GUILTY PLEASURES.

"I don't believe in guilty pleasures. If you f---ing like something, like it."

—Dave Grohl

About twenty years ago, a trashman in New York City named Nelson Molina started collecting little bits and pieces of art and unique objects that he found discarded along his route. His collection, The Trash Museum, is housed on the second floor of the Sanitation Department garage on East 99th Street, and it now features more than a thousand paintings, posters, photographs, musical instruments, toys, and other ephemera. There isn't a big unifying principle to the collection, just what Molina likes. He gets submissions from some of his fellow workers, but he says what goes on the wall and what doesn't. "I tell the guys, just bring it in and I'll decide if I can hang it." At some point, Molina painted a sign for the museum that reads TREASURE IN THE TRASH BY NELSON MOLINA.

"Dumpster diving" is one of the jobs of the artist—finding the treasure in other people's trash, sifting through the debris of our culture, paying attention to the stuff that everyone else is ignoring, and taking inspiration from the

stuff that people have tossed aside for whatever reasons. More than 400 years ago, Michel de Montaigne, in his essay "On Experience," wrote, "In my opinion, the most ordinary things, the most common and familiar, if we could see them in their true light, would turn out to be the grandest miracles . . . and the most marvelous examples." All it takes to uncover hidden gems is a clear eye, an open mind, and a willingness to search for inspiration in places other people aren't willing or able to go.

We all love things that other people think are garbage. You have to have the courage to keep loving your garbage, because what makes us unique is the diversity and breadth of our influences, the unique ways in which we mix up the parts of culture others have deemed "high" and the "low."

When you find things you genuinely enjoy, don't let anyone else make you feel bad about it. Don't feel guilty about the pleasure you take in the things you enjoy. Celebrate them.

How to

be

exceptional

THE first step is to stop trying

When you share your taste and your influences, have the guts to own all of it. Don't give in to the pressure to self-edit too much. Don't be the lame guys at the record store arguing over who's the more "authentic" punk rock band. Don't try to be hip or cool. Being open and honest about what you like is the best way to connect with people who like those things, too.

"Do what you do best and link to the rest."

—Jeff Jarvis

CREDIT IS ALWAYS DUE.

If you share the work of others, it's your duty to make sure that the creators of that work get proper credit. Crediting work in our copy-and-paste age of reblogs and retweets can seem like a futile effort, but it's worth it, and it's the right thing to do. You should always share the work of others as if it were your own, treating it with respect and care.

When we make the case for crediting our sources, most of us concentrate on the plight of the original creator of the work. But that's only half of the story—if you fail to

properly attribute work that you share, you not only rob the person who made it, you rob all the people you've shared it with. Without attribution, they have no way to dig deeper into the work or find more of it.

So, what makes for great attribution? Attribution is all about providing context for what you're sharing: what the work is, who made it, how they made it, when and where it was made, why you're sharing it, why people should care about it, and where people can see some more work like it. Attribution is about putting little museum labels next to the stuff you share.

Another form of attribution that we often neglect is where we found the work that we're sharing. It's always good practice to give a shout-out to the people who've helped you stumble onto good work and also leave a bread-crumb trail that people you're sharing with can follow back to the sources of your inspiration. I've come across so many interesting people online by following "via" and "H/T"

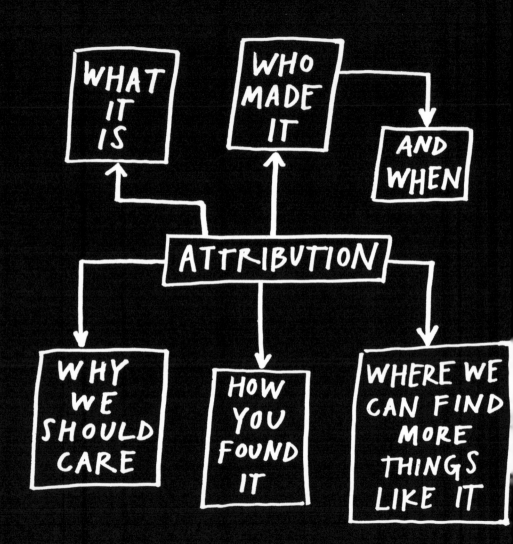

links—I'd have been robbed of a lot of these connections if it weren't for the generosity and meticulous attribution of many of the people I follow.

Online, the most important form of attribution is a hyperlink pointing back to the website of the creator of the work. This sends people who come across the work back to the original source. The number one rule of the Internet: People are lazy. If you don't include a link, no one can click it. Attribution without a link online borders on useless: 99.9 percent of people are not going to bother Googling someone's name.

All of this raises a question: What if you want to share something and you don't know where it came from or who made it? The answer: Don't share things you can't properly credit. Find the right credit, or don't share.

WORK DOESN'T SPEAK FOR ITSELF.

Close your eyes and imagine you're a wealthy collector who's just entered a gallery in an art museum. On the wall facing you there are two gigantic canvases, each more than 10 feet tall. Both paintings depict a harbor at sunset. From across the room, they look identical: the same ships, the same reflections on the water, the same sun at the same stage of setting. You go in for a closer look. You can't find a label or a museum tag anywhere. You become obsessed with the paintings, which you nickname Painting A and Painting B. You spend an hour going back and forth from

canvas to canvas, comparing brushstrokes. You can't detect a single difference.

Just as you go to fetch a museum guard or someone who can shed light on these mysterious twin masterpieces, the head curator of the museum walks in. You eagerly inquire as to the origins of your new obsessions. The curator tells you that Painting A was painted in the 17th century by a Dutch master. "And what of Painting B?" you ask. "Ah yes, Painting B," the curator says. "That's a forgery. It was copied last week by a graduate student at the local art college."

Look up at the paintings. Which canvas looks better now? Which one do you want to take home?

Art forgery is a strange phenomenon. "You might think that the pleasure you get from a painting depends on its color and its shape and its pattern," says psychology professor Paul Bloom. "And if that's right, it shouldn't matter whether it's an original or a forgery." But our brains

don't work that way. "When shown an object, or given a food, or shown a face, people's assessment of it—how much they like it, how valuable it is—is deeply affected by what you tell them about it."

In their book, *Significant Objects*, Joshua Glenn and Rob Walker recount an experiment in which they set out to test this hypothesis: "Stories are such a powerful driver of emotional value that their effect on any given object's subjective value can actually be measured objectively." First, they went out to thrift stores, flea markets, and yard sales and bought a bunch of "insignificant" objects for an average of $1.25 an object. Then, they hired a bunch of writers, both famous and not-so-famous, to invent a story "that attributed significance" to each object. Finally, they listed each object

"To fake a photograph, all you have to do is change the caption. To fake a painting, change the attribution."

—Errol Morris

on eBay, using the invented stories as the object's description, and whatever they had originally paid for the object as the auction's starting price. By the end of the experiment, they had sold $128.74 worth of trinkets for $3,612.51.

Words matter. Artists love to trot out the tired line, "My work speaks for itself," but the truth is, *our work doesn't speak for itself.* Human beings want to know where things came from, how they were made, and who made them. The stories you tell about the work you do have a huge effect on how people feel and what they understand about your work, and how people feel and what they understand about your work affects how they value it.

"Why should we describe the frustrations and turning points in the lab, or all the hours of groundwork and failed images that precede the final outcomes?" asks artist Rachel Sussman. "Because, rarified exceptions aside, our audience is a human one, and humans want to connect. Personal stories

PICTURES CAN SAY WHATEVER WE WANT THEM TO SAY.

MOUNTAIN

SHARK FIN

STALAGMITE

WIZARD HAT

TORTILLA CHIP

(YOUR CAPTION GOES HERE.

can make the complex more tangible, spark associations, and offer entry into things that might otherwise leave one cold."

Your work doesn't exist in a vacuum. Whether you realize it or not, you're already telling a story about your work. Every email you send, every text, every conversation, every blog comment, every tweet, every photo, every video—they're all bits and pieces of a multimedia narrative you're constantly constructing. If you want to be more effective when sharing yourself and your work, you need to become a better storyteller. You need to know what a good story is and how to tell one.

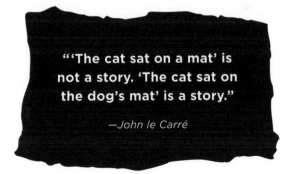

"'The cat sat on a mat' is not a story. 'The cat sat on the dog's mat' is a story."

—*John le Carré*

STRUCTURE IS EVERYTHING.

"In the first act, you get your hero up a tree. The second act, you throw rocks at him. For the third act, you let him down."

—*George Abbott*

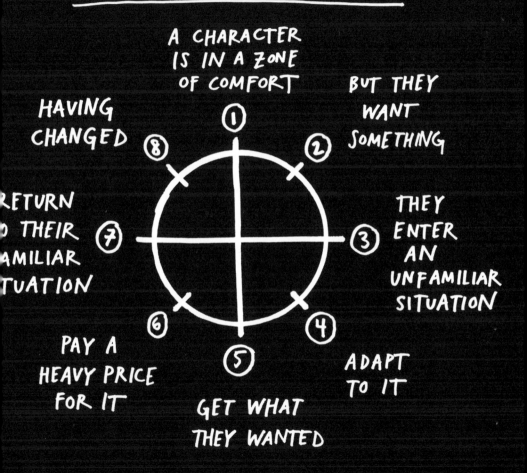

The most important part of a story is its structure. A good story structure is tidy, sturdy, and logical. Unfortunately, most of life is messy, uncertain, and illogical. A lot of our raw experiences don't fit neatly into a traditional fairy tale or a Hollywood plot. Sometimes we have to do a lot of cropping and editing to fit our lives into something that resembles a story. If you study the structure of stories, you start to see how they work, and once you know how they work, you can then start stealing story structures and filling them in with characters, situations, and settings from your own life.

Most story structures can be traced back to myths and fairy tales. Emma Coats, a former storyboard artist at Pixar, outlined the basic structure of a fairy tale as a kind of Mad Lib that you can fill in with your own elements: "Once upon a time, there was _____. Every day, _____. One day, _____. Because of that, _____. Because of that, _____. Until finally, _____." Pick your favorite story and try to fill in the blanks. It's striking how often it works.

Philosopher Aristotle said a story had a beginning, a middle, and an end. Author John Gardner said the basic plot of nearly all stories is this: "A character wants something, goes after it despite opposition (perhaps including his own doubts), and so arrives at a win, lose, or draw." I like Gardner's plot formula because it's also the shape of most creative work: You get a great idea, you go through the hard work of executing the idea, and then you release the idea out into the world, coming to a win, lose, or draw. Sometimes the idea succeeds, sometimes it fails, and more often than not, it does nothing at all. This simple formula can be applied to almost any type of work project: There's the initial problem, the work done to solve the problem, and the solution.

Of course, when you're in the middle of a story, as most of us in life are, you don't know if it's a story at all, because you don't know how far into it you are, and you don't know how it's going to end. Fortunately, there's a way to tell open-

KURT VONNEGUT'S STORY GRAPHS

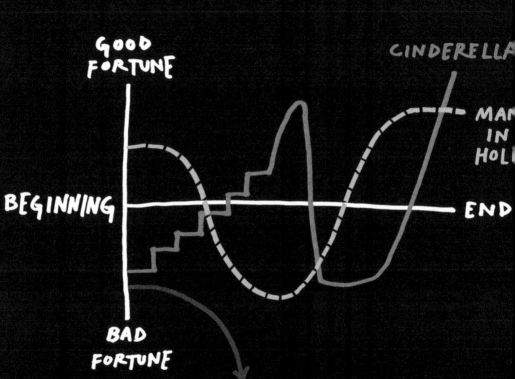

GOOD
FORTUNE

CINDERELLA

MAN
IN
HOLE

BEGINNING

END

BAD
FORTUNE

KAFKA'S "METAMORPHOSIS"

ended stories, where we acknowledge that we're smack-dab in the middle of a story, and we don't know how it all ends.

Every client presentation, every personal essay, every cover letter, every fund-raising request—they're all *pitches*. They're stories with the endings chopped off. A good pitch is set up in three acts: The first act is the past, the second act is the present, and the third act is the future. The first act is where you've been—what you want, how you came to want it, and what you've done so far to get it. The second act is where you are now in your work and how you've worked hard and used up most of your resources. The third act is where you're going, and how exactly the person you're pitching can help you get there. Like a Choose Your Own Adventure book, this story shape effectively turns your listener into the hero who gets to decide how it ends.

Whether you're telling a finished or unfinished story, always keep your audience in mind. Speak to them directly in plain language. Value their time. Be brief. Learn to speak. Learn

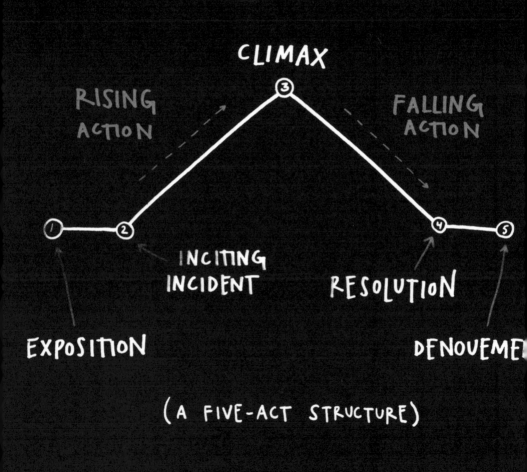

to write. Use spell-check. You're never "keeping it real" with your lack of proofreading and punctuation, you're keeping it unintelligible.

Everybody loves a good story, but good storytelling doesn't come easy to everybody. It's a skill that takes a lifetime to master. So study the great stories and then go find some of your own. Your stories will get better the more you tell them.

"You got to make your case."

—Kanye West

TALK ABOUT YOURSELF AT PARTIES.

We've all been there. You're standing at a party, enjoying your drink, when a stranger approaches, introduces herself, and asks the dreaded question, "So, what do you do?"

If you happen to be a doctor or a teacher or a lawyer or a plumber, congratulations. You may proceed without caution. For the rest of us, we're going to need to practice our answers.

Artists have it the worst. If you answer, "I'm a writer," for example, there's a very good chance that the next question will be, "Oh, have you published anything?" which is actually a veiled way of asking, "Do you make any money off that?"

The way to get over the awkwardness in these situations is to stop treating them as interrogations, and start treating them as opportunities to connect with somebody by honestly and humbly explaining what it is that you do. You should be able to explain your work to a kindergartner, a senior citizen, and everybody in between. Of course, you always need to keep your audience in mind: The way you explain your work to your buddies at the bar is not the way you explain your work to your mother.

Just because you're trying to tell a good story about yourself doesn't mean you're inventing fiction. Stick to nonfiction. Tell the truth and tell it with dignity and self-respect. If you're a student, say you're a student. If you work a day job,

HELLO
my name is

say you work a day job. (For years, I said, "By day I'm a web designer, and by night I write poetry.") If you have a weird hybrid job, say something like, "I'm a writer who draws." (I stole that bio from the cartoonist Saul Steinberg.) If you're unemployed, say so, and mention what kind of work you're looking for. If you're employed, but you don't feel good about your job title, ask yourself why that is. Maybe you're in the wrong line of work, or maybe you're not doing the work you're supposed to be doing. (There were many years where answering, "I'm a writer," felt wrong, because I wasn't actually writing.) Remember what the author George Orwell wrote: "Autobiography is only to be trusted when it reveals something disgraceful."

Have empathy for your audience. Anticipate blank stares. Be ready for more questions. Answer patiently and politely.

All the same principles apply when you start writing your bio. Bios are not the place to practice your creativity. We all like to think we're more complex than a two-sentence

explanation, but a two-sentence explanation is usually what the world wants from us. Keep it short and sweet.

Strike all the adjectives from your bio. If you take photos, you're not an "aspiring" photographer, and you're not an "amazing" photographer, either. You're a photographer. Don't get cute. Don't brag. Just state the facts.

One more thing: Unless you are actually a ninja, a guru, or a rock star, don't ever use any of those terms in your bio. Ever.

"Whatever we say, we're always talking about ourselves."

—Alison Bechdel

"The impulse to keep to yourself what you have learned is not only shameful, it is destructive. Anything you do not give freely and abundantly becomes lost to you. You open your safe and find ashes."

—*Annie Dillard*

SHARE YOUR TRADE SECRETS.

The world of barbecue is notoriously secretive and competitive, so it was a little bit of a shock last winter for me to be standing behind the legendary Franklin Barbecue here in Austin, Texas, watching pitmaster and barbecue wizard Aaron Franklin explain how he smokes his famous ribs in front of a camera crew. My friend Sara Robertson, a producer at the local PBS station KLRU, had invited me to watch a taping of *BBQ with Franklin*—a crowdfunded YouTube series designed to take viewers through every step of the barbecue process. In the series, Franklin explains how

to modify an off-the-shelf smoker, how to select the right wood, how to build a fire, how to select a cut of meat, what temperature to smoke the meat at, and how to slice up the finished product.

I started eating at Franklin Barbecue in 2010 when it was served out of a trailer off Interstate 35. In only three years, Franklin has become one of the most famous barbecue joints in the world. (*Bon Appétit* called it "the best BBQ in Texas, if not America.") Six days a week, rain or 100-degree sunshine, there's a line that goes around the block. And each one of those days, they sell out of meat. If ever it seemed like there was a business that would be intent to keep its secrets to itself, it would be this one.

When I got to talk to Aaron and his wife, Stacy, during a break in filming, they explained that the technique of barbecue is actually very simple, but it takes years and years to master. There's an intuition that you only gain through the repetition of practice. Aaron told me that he trains

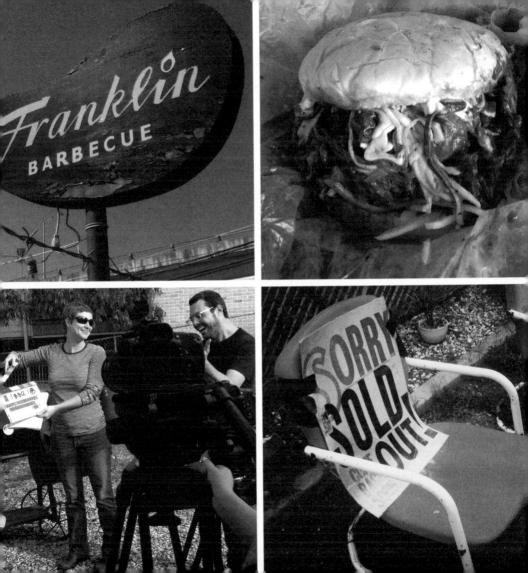

all his employees the same way, but when he cuts into a brisket, he can tell you exactly who did the smoking.

Teaching doesn't mean instant competition. Just because you know the master's technique doesn't mean you're going to be able to emulate it right away. You can watch Franklin's tutorials over and over, but are you ready to start spending 22 hours a day smoking meat that will sell out in two hours? Probably not. If you're me, you'll pay the $13 a pound even more gladly.

The Franklins also just genuinely love barbecue, and they go out of their way to share their knowledge. People often stop by with their own attempts at brisket, and Aaron is always gracious and patient when answering their questions. You don't get the feeling that any of this is calculated, it's just the way they operate—they started out as beginners, and so they feel an obligation to pass on what they've learned.

Of course, many chefs and restaurateurs have become rich and famous by sharing their recipes and their techniques.

In their book, *Rework*, Jason Fried and David Heinemeier Hansson encourage businesses to emulate chefs by out-teaching their competition. "What do you do? What are your 'recipes'? What's your 'cookbook'? What can you tell the world about how you operate that's informative, educational, and promotional?" They encourage businesses to figure out the equivalent of their own cooking show.

Think about what you can share from your process that would inform the people you're trying to reach. Have you learned a craft? What are your techniques? Are you skilled at using certain tools and materials? What kind of knowledge comes along with your job?

The minute you learn something, turn around and teach it to others. Share your reading list. Point to helpful reference materials. Create some tutorials and post them online. Use pictures, words, and video. Take people step-by-step through part of your process. As blogger Kathy Sierra says, "Make people better at something they want to be better at."

Teaching people doesn't subtract value from what you do, it actually adds to it. When you teach someone how to do your work, you are, in effect, generating more interest in your work. People feel closer to your work because you're letting them in on what you know.

Best of all, when you share your knowledge and your work with others, you receive an education in return. Author Christopher Hitchens said that the great thing about putting out a book is that "it brings you into contact with people whose opinions you should have canvassed before you ever pressed pen to paper. They write to you. They telephone you. They come to your bookstore events and give you things to read that you should have read already." He said that having his work out in the world was "a free education that goes on for a lifetime."

"When people realize they're being listened to, they tell you things."

—*Richard Ford*

SHUT UP AND LISTEN.

When I was in college, there was always one classmate in every creative writing workshop who claimed, "I love to write, but I don't like to read." It was evident right away that you could pretty much write that kid off completely. As every writer knows, if you want to be a writer, you have to be a reader first.

"The writing community is full of lame-o people who want to be published in journals even though they don't read the magazines that they want to be published in," says writer Dan Chaon. "These people deserve the rejections that they

will undoubtedly receive, and no one should feel sorry for them when they cry about how they can't get anyone to accept their stories."

I call these people human spam. They're everywhere, and they exist in every profession. They don't want to pay their dues, they want their piece right here, right now. They don't want to listen to your ideas; they want to tell you theirs. They don't want to go to shows, but they thrust flyers at you on the sidewalk and scream at you to come to theirs. You should feel pity for these people and their delusions. At some point, they didn't get the memo that the world owes none of us anything.

Of course, you don't have to be a nobody to be human spam—I've watched plenty of interesting, successful people slowly turn into it. The world becomes all about them and their work. They can't find the time to be interested in anything other than themselves.

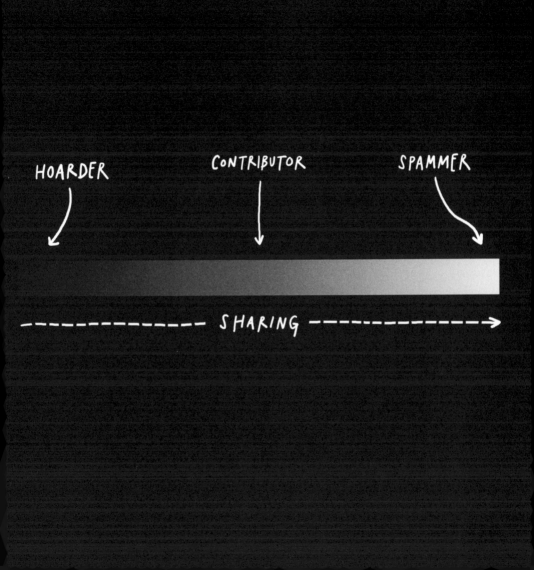

No matter how famous they get, the forward-thinking artists of today aren't just looking for fans or passive consumers of their work, they're looking for potential collaborators, or co-conspirators. These artists acknowledge that good work isn't created in a vacuum, and that the experience of art is always a two-way street, incomplete without feedback. These artists hang out online and answer questions. They ask for reading recommendations. They chat with fans about the stuff they love.

The music producer Adrian Younge was hanging out on Twitter one day and tweeted, "Who is better: The Dramatics or The Delfonics?" As his followers erupted in a debate over the two soul groups, one follower mentioned that the lead singer of The Delfonics, William Hart, was a friend of his dad's and that Hart just happened to be a fan of Younge's music. The follower suggested that the two should collaborate. "To make a long story short," Younge says, "a day later, I'm on the phone with William Hart and

we're speaking for like two hours . . . we hit it off in a way that was just cosmic." Younge then produced a brand-new record with Hart, *Adrian Younge Presents The Delfonics*.

That story is great for two reasons. One, it's the only story of an album I know of whose existence can be traced to a single tweet. Two, it shows what happens when a musician interacts with his fans *on the level of a fan himself.*

If you want fans, you have to be a fan first. If you want to be accepted by a community, you have to first be a good citizen of that community. If you're only pointing to your own stuff online, you're doing it wrong. You have to be a connector. The writer Blake Butler calls this *being an open node.* If you want to get, you have to give. If you want to be noticed, you have to notice. Shut up and listen once in a while. Be thoughtful. Be considerate. Don't turn into human spam. Be an open node.

"What you want is to follow and be followed by human beings who care about issues you care about. This thing we make together. This thing is about hearts and minds, not eyeballs."

—Jeffrey Zeldman

YOU WANT HEARTS, NOT EYEBALLS.

Stop worrying about how many people follow you online and start worrying about the quality of people who follow you. Don't waste your time reading articles about how to get more followers. Don't waste time following people online just because you think it'll get you somewhere. Don't talk to people you don't want to talk to, and don't talk about stuff you don't want to talk about.

If you want followers, be someone worth following. Barry Hannah said to one of his students, "Have you tried making

be a good date to

everybody

look ,

Listen

learn

how to work with other

brains

give credit

and

get out of the way

yourself a more interesting person?" This seems like a really mean thing to say, unless you think of the word *interesting* the way writer Lawrence Weschler does: For him, to be "interest-ing" is to be curious and attentive, and to practice "the continual projection of interest." To put it more simply: If you want to be interesting, you have to be interested.

It is actually true that life is all about "who you know." But who you know is largely dependent on who you are and what you do, and the people you know can't do anything for you if you're not doing good work. "Connections don't mean shit," says record producer Steve Albini. "I've never had any connections that weren't a natural outgrowth of doing things I was doing anyway." Albini laments how many people waste time and energy trying to make connections instead of getting good at what they do, when "being good at things is the only thing that earns you clout or connections."

Make stuff you love and talk about stuff you love and you'll attract people who love that kind of stuff. It's that simple.

Don't be creepy. Don't be a jerk. Don't waste people's time. Don't ask too much. And don't ever ever ask people to follow you. "Follow me back?" is the saddest question on the Internet.

THE VAMPIRE TEST

> "Whatever excites you, go do it. Whatever drains you, stop doing it."
>
> —*Derek Sivers*

There's a funny story in John Richardson's biography, *A Life of Picasso*. Pablo Picasso was notorious for sucking all the energy out of the people he met. His granddaughter Marina claimed that he squeezed people like one of his tubes of oil paints. You'd have a great time hanging out all day with Picasso, and then you'd go home nervous and exhausted, and Picasso would go back to his studio and paint all night, using the energy he'd sucked out of you.

Most people put up with this because they got to hang out with Picasso all day, but not Constantin Brancusi, the Romanian-born sculptor. Brancusi hailed from the Carpathian Mountains, and he knew a vampire when he saw one. He was not going to have his energy or the fruits of his energy juiced by Picasso, so he refused to have anything to do with him.

Brancusi practiced what I call The Vampire Test. It's a simple way to know who you should let in and out of your life. If, after hanging out with someone you feel worn out

and depleted, that person is a vampire. If, after hanging out with someone you still feel full of energy, that person is *not* a vampire. Of course, The Vampire Test works on many things in our lives, not just people—you can apply it to jobs, hobbies, places, etc.

Vampires cannot be cured. Should you find yourself in the presence of a vampire, be like Brancusi, and banish it from your life forever.

"Part of the act of creating is in discovering your own kind. They are everywhere. But don't look for them in the wrong places."

—*Henry Miller*

IDENTIFY YOUR FELLOW KNUCKLEBALLERS.

I recently became fascinated by the baseball pitcher R. A. Dickey. Dickey's pitch is the knuckleball—a slow, awkward pitch that's really hard to throw with any kind of consistency. When a pitcher throws a knuckleball, he releases the baseball with as little spin as possible. The air current moves against the baseball's seams, and it makes the baseball move really strangely. Once a good knuckleball is

thrown, it's equally unpredictable to the batter, the catcher, *and* the pitcher who threw it. (Sounds a lot like the creative process, huh?)

Knuckleball pitchers are basically the ugly ducklings of baseball. Because there are so few of them, they actually form a kind of brotherhood, and they often get together and share tips with one another. Dickey writes about how rare this is in his memoir, *Wherever I Wind Up*: "There's no chance that an opposing pitcher, no matter how nice a guy, is going to invite me to watch how he grips and throws his split-fingered fastball or slider. Those are state secrets." With his fellow knuckleballers, however, things are different: "Knuckleballers don't keep secrets. It's as if we have a greater mission beyond our own fortunes. And that mission is to pass it on, to keep the pitch alive."

As you put yourself and your work out there, you will run into your fellow knuckleballers. These are your real peers— the people who share your obsessions, the people who share

when you pin
your
kind
you get

your team.

a similar mission to your own, the people with whom you share a mutual respect. There will only be a handful or so of them, but they're so, so important. Do what you can to nurture your relationships with these people. Sing their praises to the universe. Invite them to collaborate. Show them work before you show anybody else. Call them on the phone and share your secrets. Keep them as close as you can.

"It's all about paying attention. Attention is vitality. It connects you with others."

—*Susan Sontag*

MEET UP IN MEATSPACE.

"You and I will be around
a lot longer than Twitter,
and nothing substitutes
face to face."

—Rob Delaney

It freaks me out a little bit how many of my very favorite people in the world came into my life as ones and zeros.

I love meeting my online friends "IRL." (IRL = *in real life*.) There's never any small talk—we know all about one another and what one another does. We can just sip beer or some other social lubricant and talk about big ideas. There's been a few times that I've asked people what they think the best thing about being online is, and they'll point around the table and say, "What we're doing here."

I love the phenomenon of "meetups"—an online community throwing a party at a bar or a restaurant and inviting everybody to show up at a certain place and time. There's a lot of these kinds of events in Austin, and I'm sure there's a bunch in your town, too. (If there aren't any—set one up!) They're a lot less stressful than traditional forms of networking because you already know a lot of the people who show up, and you've seen their work.

Of course, a meetup doesn't have to comprise a huge group of people. If you've been friends for a while with somebody online and you live in the same town, ask them if they want to grab a coffee. If you want to go all out, offer to buy them lunch. If you're traveling, let your online friends know you're going to be in town. I like asking my artist friends to take me to their favorite art museums and asking my writer friends to take me to their favorite bookstore. If we get sick of talking to one another, we can browse, and if we get sick of browsing, we can grab a coffee in the café.

Meeting people online is awesome, but turning them into IRL friends is even better.

TO
PUNCH.

"I ain't going to give up. Every time you think I'm one place, I'm going to show up someplace else. I come pre-hated. Take your best shot."

—*Cyndi Lauper*

LET 'EM TAKE THEIR BEST SHOT.

Designer Mike Monteiro says that the most valuable skill he picked up in art school was learning how to take a punch. He and his fellow classmates were absolutely brutal during critiques. "We were basically trying to see if we could get each other to drop out of school." Those vicious critiques taught him not to take criticism personally.

When you put your work out into the world, you have to be ready for the good, the bad, and the ugly. The more people come across your work, the more criticism you'll face. Here's how to take punches:

Relax and breathe. The trouble with imaginative people is that we're good at picturing the worst that could happen

STRENGTHEN YOUR NECK

BREATHE

RELAX

PROTECT YOUR VULNERABLE AREAS

KEEP YOUR BALANCE

ROLL WITH THE PUNCHES

to us. Fear is often just the imagination taking a wrong turn. Bad criticism is not the end of the world. As far as I know, no one has ever died from a bad review. Take a deep breath and accept whatever comes. (Consider practicing meditation—it works for me.)

Strengthen your neck. The way to be able to take a punch is to practice getting hit a lot. Put out a lot of work. Let people take their best shot at it. Then make even more work and keep putting it out there. The more criticism you take, the more you realize it can't hurt you.

Roll with the punches. Keep moving. Every piece of criticism is an opportunity for new work. You can't control what sort of criticism you receive, but you can control how you react to it. Sometimes when people hate something about your work, it's fun to push that element even further. To make something they'd hate even more. Having your work hated by certain people is a badge of honor.

Protect your vulnerable areas. If you have work that is too sensitive or too close to you to be exposed to criticism, keep it hidden. But remember what writer Colin Marshall says: "Compulsive avoidance of embarrassment is a form of suicide." If you spend your life avoiding vulnerability, you and your work will never truly connect with other people.

Keep your balance. You have to remember that your work is something you do, not who you are. This is especially hard for artists to accept, as so much of what they do is personal. Keep close to your family, friends, and the people who love you for you, not just the work.

> **"The trick is not caring what EVERYBODY thinks of you and just caring about what the RIGHT people think of you."**
>
> *—Brian Michael Bendis*

DON'T FEED THE TROLLS.

The first step in evaluating feedback is sizing up who it came from. You want feedback from people who care about you and what you do. Be extra wary of feedback from anybody who falls outside of that circle.

A troll is a person who isn't interested in improving your work, only provoking you with hateful, aggressive, or upsetting talk. You will gain nothing by engaging with these people. Don't feed them, and they'll usually go away.

Trolls can come out of nowhere and pop up in unexpected places. Right after my son was born, this woman

(presumably a follower, if not a fan) got on Twitter and sent me half a dozen tweets about how she just knew my book *Steal Like an Artist* was written by somebody without kids, and *just you wait, mister*. She then proceeded to quote passages from the book, followed by little ejaculations like, "Ha! Try that when you're up at three a.m. with a crying baby!"

Now, I have been on the Internet a long time. I get a lot of emails from people who are, as far as I can tell, sad, awful, or completely insane. I have a pretty good mental firewall that filters what I let get to me.

This woman got to me.

Because, of course, the worst troll is the one that lives in your head. It's the voice that tells you you're not good enough, that you suck, and that you'll never amount to anything. It's the voice that told me I'd never write another good word after becoming a father. It is one thing to have

clown for
A
th

comments

outnumber
ideas.

the troll in your brain, it is another thing to have a stranger hold a megaphone up to it and let it shout.

Do you have a troll problem? Use the BLOCK button on social media sites. Delete nasty comments. My wife is fond of saying, "If someone took a dump in your living room, you wouldn't let it sit there, would you?" Nasty comments are the same—they should be scooped up and thrown in the trash.

At some point, you might consider turning off comments completely. Having a form for comments is the same as inviting comments. "There's never a space under paintings in a gallery where someone writes their opinion," says cartoonist Natalie Dee. "When you get to the end of a book, you don't have to see what everyone else thought of it." Let people contact you directly or let them copy your work over to their own spaces and talk about it all they want.

"Sellout . . . I'm not crazy about that word. We're all entrepreneurs. To me, I don't care if you own a furniture store or whatever—the best sign you can put up is SOLD OUT."

—Bill Withers

EVEN THE RENAISSANCE HAD TO BE FUNDED.

People need to eat and pay the rent. "An amateur is an artist who supports himself with outside jobs which enable him to paint," said artist Ben Shahn. "A professional is someone whose wife works to enable him to paint." Whether an artist makes money off his work or not, money has to come from somewhere, be it a day job, a wealthy spouse, a trust fund, an arts grant, or a patron.

We all have to get over our "starving artist" romanticism and the idea that touching money inherently corrupts

creativity. Some of our most meaningful and most cherished cultural artifacts were made for money. Michelangelo painted the Sistine Chapel ceiling because the pope commissioned him. Mario Puzo wrote *The Godfather* to make money: He was 45 years old, tired of being an artist, and owed $20,000 to assorted relatives, banks, bookmakers, and shylocks. Paul McCartney has said that he and John Lennon used to sit down before a Beatles songwriting session and say, "Now, let's write a swimming pool."

Everybody says they want artists to make money, and then when they do, everybody hates them for it. The word *sellout* is spit out by the bitterest, smallest parts of ourselves. Don't be one of those horrible fans who stops listening to your favorite band just because they have a hit single. Don't write off your friends because they've had a little bit of success. Don't be jealous when the people you like do well— celebrate their victory as if it's your own.

PASS AROUND THE HAT.

"I'd love to sell out completely. It's just that nobody has been willing to buy."

—John Waters

When an audience starts gathering for the work that you're freely putting into the world, you might eventually want to take the leap of turning them into patrons. The easiest way to do this is to simply ask for donations: Put a little virtual tip jar or a DONATE NOW button on your website. These links do well with a little bit of human copy, such as "Like this? Buy me a coffee." This is a very simple transaction, which is the equivalent of a band passing a hat during a gig—if people are digging what you do, they'll throw a few bucks your way.

If you have work you want to attempt that requires some up-front capital, platforms like Kickstarter and Indiegogo make it easy to run fund-raising campaigns with tiered rewards for donors. It's important to note that these platforms work best when you've already gathered a group of people who are into what you do. The musician Amanda Palmer has had wild success turning her audience into patrons: After showing her work, sharing her music freely,

and cultivating relationships with her fans, she asked for $100,000 from them to help record her next album. They gave her more than a million dollars.

There are certainly some strings attached to crowdfunding—when people become patrons, they feel, not altogether wrongly, that they should have some say in how their money is being used. It's partly for this reason that my business model is still pretty old-fashioned: I make something and sell it for money. Instead of having a DONATE NOW button on my website, I have BUY NOW and HIRE ME buttons. But even though I operate more like a traditional salesman, I do use some of the same tactics as crowdfunders: I try to be open about my process, connect with my audience, and ask them to support me by buying the things I'm selling.

Beware of selling the things that you love: When people are asked to get out their wallets, you find out how much they really value what you do. My friend John T. Unger tells

this terrific story from his days as a street poet. He would do a poetry reading and afterward some guy would come up to him and say, "Your poem changed my life, man!" And John would say, "Oh, thanks. Want to buy a book? It's five dollars." And the guy would take the book, hand it back to John, and say, "Nah, that's okay." To which John would respond, "Geez, how much is your life worth?"

Whether you ask for donations, crowdfund, or sell your products or services, asking for money in return for your work is a leap you want to take only when you feel confident that you're putting work out into the world that you think is truly worth something. Don't be afraid to charge for your work, but put a price on it that you think is fair.

KEEP A MAILING LIST.

Even if you don't have anything to sell right now, you should always be collecting email addresses from people who come across your work and want to stay in touch. Why email? You'll notice a pattern with technology—often the most boring and utilitarian technologies are the ones that stick around the longest. Email is decades and decades old, but it's nowhere close to being dead. Even though almost everybody hates it, everybody has an email address. And unlike RSS and social media feeds, if you send someone an email, it will land in her inbox, and it will come to her attention. She might not open it, but she definitely has to go to the trouble of deleting it.

I know people who run multimillion-dollar businesses off of their mailing lists. The model is very simple: They give away great stuff on their sites, they collect emails, and then when they have something remarkable to share or sell, they send an email. You'd be amazed at how well the model works.

Keep your own list, or get an account with an email newsletter company like MailChimp and put a little sign-up widget on every page of your website. Write a little bit of copy to encourage people to sign up. Be clear about what they can expect, whether you'll be sending daily, monthly, or infrequent updates. *Never ever add someone's email address to your mailing list without her permission.*

The people who sign up for your list will be some of your biggest supporters, just by the simple fact that they signed up for the potential to be spammed by you. Don't betray their trust and don't push your luck. Build your list and treat it with respect. It will come in handy.

"We don't make movies to make money, we make money to make more movies."

—*Walt Disney*

MAKE MORE WORK FOR YOURSELF.

Some awful people use the term *sellout* to include any artist who dares to have any ambition whatsoever. They'll say you're a sellout if you try to make it outside your hometown. They say you're a sellout if you buy better equipment. They'll say you're a sellout if you try anything new at all.

"There is a point in one's life when one cares about selling out and not selling out," writes author Dave Eggers. "Thankfully, for some, this all passes." What really matters, Eggers says, is doing good work and taking advantage of every opportunity that comes your way. "I really like saying yes. I like new things, projects, plans, getting people

together and doing something, trying something, even when it's corny or stupid." The people who holler "Sellout!" are all hollering "No!" They're the people who don't want things to ever change.

Yet a life of creativity is all about change—moving forward, taking chances, exploring new frontiers. "The real risk is in not changing," said saxophonist John Coltrane. "I have to feel that I'm after something. If I make money, fine. But I'd rather be striving. It's the striving, man, it's that I want."

Be ambitious. Keep yourself busy. Think bigger. Expand your audience. Don't hobble yourself in the name of "keeping it real," or "not selling out." Try new things. If an opportunity comes along that will allow you to do more of the kind of work you want to do, say *Yes*. If an opportunity comes along that would mean more money, but less of the kind of work you want to do, say *No*.

"There is no misery in art.
All art is about saying yes,
and all art is about its own making."

—*John Currin*

PAY IT FORWARD.

When you have success, it's important to use any dough, clout, or platform you've acquired to help along the work of the people who've helped you get to where you are. Extol your teachers, your mentors, your heroes, your influences, your peers, and your fans. Give them a chance to share their own work. Throw opportunities their way.

There's a caveat to all this: As a human being, you have a finite amount of time and attention. At some point, you have to switch from saying "yes" a lot to saying "no" a lot. "The biggest problem of success is that the world conspires

to stop you doing the thing that you do, because you are successful," writes author Neil Gaiman. "There was a day when I looked up and realised that I had become someone who professionally replied to email, and who wrote as a hobby. I started answering fewer emails, and was relieved to find I was writing much more."

I find myself in the weird position now where I get way more email from people than I could ever answer and still do everything I need to do. The way I get over my guilt about not answering email is to hold *office hours*. Once a month, I make myself available so that anybody can ask me anything on my website, and I try to give thoughtful answers that I then post so anyone can see.

You just have to be as generous as you can, but selfish enough to get your work done.

"Above all, recognize that if you have had success, you have also had luck—and with luck comes obligation. You owe a debt, and not just to your gods. You owe a debt to the unlucky."

—*Michael Lewis*

DON'T QUIT YOUR SHOW.

Every career is full of ups and downs, and just like with stories, when you're in the middle of living out your life and career, you don't know whether you're up or down or what's about to happen next. "If you want a happy ending," actor Orson Welles wrote, "that depends, of course, on where you stop your story." Author F. Scott Fitzgerald wrote, "There are no second acts in American life," but if you look around you'll notice that not only are there second acts, there are third, fourth, and even fifth ones. (If you're reading the obituaries every morning, by now you already know this.)

The people who get what they're after are very often the ones who just stick around long enough. It's very important not to quit prematurely. The comedian Dave Chappelle was doing a stand-up gig in Dallas not long ago and he started joking about walking away from his lucrative deal with Comedy Central for his program, *Chappelle's Show*. He said he was asked to come to a high school class and give some advice. "I guess, whatever you do, don't quit your show," he said. "Life is very hard without a show, kids."

"In our business you don't quit," says comedian Joan Rivers. "You're holding on to the ladder. When they cut off your hands, hold on with your elbow. When they cut off your arms, hold on with your teeth. You don't quit because you don't know where the next job is coming from."

You can't plan on anything; you can only go about your work, as Isak Dinesen wrote, "every day, without hope or

> **"Work is never finished, only abandoned."**
>
> —*Paul Valéry*

Just keep going.

despair." You can't count on success; you can only leave open the possibility for it, and be ready to jump on and take the ride when it comes for you.

One time my coworker John Croslin and I came back from our lunch break and our building's parking lot was completely full. We circled the sweltering lot with a few other cars for what seemed like ages, and just when we were about to give up, a spot opened and John pulled right in. As he shut off the car he said, "You gotta play till the ninth inning, man." Good advice for both the parking lot and life in general.

CHAIN-SMOKE.

A few years ago, there was a reality TV show on Bravo called *Work of Art*, where every week artists competed against one another for some cash and a chance at landing a museum show. If you won the week's challenge, you were granted immunity for the next round, and you could breathe a little easier for the next week. The host would say something like, "Congratulations, Austin. You've created a work of art. You have immunity for the next challenge."

If only life were like "reality" TV! As every author knows, your last book isn't going to write your next one for you. A successful or failed project is no guarantee of another success or failure. Whether you've just won big or lost big, you still have to face the question "What's next?"

If you look to artists who've managed to achieve lifelong careers, you detect the same pattern: They all have been able to persevere, regardless of success or failure. Singer/songwriter Joni Mitchell said that whatever she felt was the weak link in her last project gave her inspiration for the next. Bob Pollard, the lead singer and songwriter for Guided by Voices, says he never gets writer's block because he never stops writing. Author Ernest Hemingway would stop in the middle of a sentence at the end of his day's work so he knew where to start in the morning. If Anthony Trollope finished a novel in the middle of his daily 3-hour writing session, he'd begin writing a new one until his time was up.

Add all this together and you get a way of working I call chain-smoking. You avoid stalling out in your career by never losing momentum. Here's how you do it: Instead of taking a break in between projects, waiting for feedback, and worrying about what's next, use the end of one project to light up the next one. Just do the work that's in front of you, and when it's finished, ask yourself what you missed, what you could've done better, or what you couldn't get to, and jump right into the next project.

"We work because it's a chain reaction, each subject leads to the next."

—*Charles Eames*

GO AWAY SO YOU CAN COME BACK.

> "The minute you stop wanting
> something you get it."
>
> —Andy Warhol

Chain-smoking is a great way to keep going, but at some point, you might burn out and need to go looking for a match. The best time to find one is while taking a sabbatical.

The designer Stefan Sagmeister swears by the power of the *sabbatical*—every seven years, he shuts down his studio and takes a year off. His thinking is that we dedicate the first 25 years or so of our lives to learning, the next 40 to work, and the last 15 to retirement, so why not take 5 years off retirement and use them to break up the work years? He says the sabbatical has turned out to be invaluable to his work: "Everything that we designed in the seven years following the first sabbatical had its roots in thinking done during that sabbatical."

I, too, have experienced this phenomenon: I spent my first two years out of college working a nondemanding part-time job in a library, doing nothing but reading and writing and drawing. I'd say I've spent the years since executing a lot

what are you hoping to express
if all
you see is four walls?

consider whether to cancel

flee

the

office

to pick up a signal

cut off mobile
service

don't die

simply
disappear

A while

of the ideas I had during that period. Now I'm hitting my seven-year itch, and I find myself needing another period to recharge and get inspired again.

Of course, a sabbatical isn't something you can pull off without any preparation. Sagmeister says his first sabbatical took two years of planning and budgeting, and his clients were warned a full year in advance. And the reality is that most of us just don't have the flexibility in our lives to be able to walk away from our work for a full year. Thankfully, we can all take *practical* sabbaticals—daily, weekly, or monthly breaks where we walk away from our work completely. Writer Gina Trapani has pointed out three prime spots to turn off our brains and take a break from our connected lives:

• **Commute.** A moving train or subway car is the perfect time to write, doodle, read, or just stare out the window. (If you commute by car, audiobooks are a great way to safely

tune out.) A commute happens twice a day, and it nicely separates our work life from our home life.

• **Exercise.** Using our body relaxes our mind, and when our mind gets relaxed, it opens up to having new thoughts. Jump on the treadmill and let your mind go. If you're like me and you hate exercise, get a dog—dogs won't let you get away with missing a day.

• **Nature.** Go to a park. Take a hike. Dig in your garden. Get outside in the fresh air. Disconnect from anything and everything electronic.

It's very important to separate your work from the rest of your life. As my wife said to me, "If you never *go* to work, you never get to *leave* work."

"Every two or three years,
I knock off for a while.
That way, I'm constantly the
new girl in the whorehouse."

—*Robert Mitchum*

~~START OVER.~~
BEGIN AGAIN.

"Whenever Picasso learned how to do something, he abandoned it."

—*Milton Glaser*

When you feel like you've learned whatever there is to learn from what you're doing, it's time to change course and find something new to learn so that you can move forward. You can't be content with mastery; you have to push yourself to become a student again. "Anyone who isn't embarrassed of who they were last year probably isn't learning enough," writes author Alain de Botton.

The minute comedian George Carlin finished recording one of his HBO stand-up specials, he'd throw out all his old jokes and start from scratch on a new hour of material for the next special. He did this year after year. "An artist has an obligation to be *en route*— to be going somewhere," he said. "There's a journey involved. . . . It keeps you trying to be fresh, trying to be new, trying to call on yourself a little more." Carlin learned that when you get rid of old material, you push yourself further and come up with something better. When you throw out old work, what you're really doing is making room for new work.

on
to
the next
pipe dream,

You have to have the courage to get rid of work and rethink things completely. "I need to sort of tear down everything I've done and rebuild from scratch," said director Steven Soderbergh about his upcoming retirement from making films. "Not because I've figured everything out, I've just figured out what I can't figure out and I need to tear it down and start over again."

The thing is, you never really start over. You don't lose all the work that's come before. Even if you try to toss it aside, the lessons that you've learned from it will seep into what you do next.

So don't think of it as starting over. Think of it as beginning again. Go back to chapter one—literally!—and become an amateur. Look for something new to learn, and when you find it, dedicate yourself to learning it out in the open. Document your progress and share as you go so that others can learn along with you. Show your work, and when the right people show up, pay close attention to them, because they'll have a lot to show you.

WHAT NOW? {

- GO ONLINE AND POST WHAT YOU'RE WORKING ON RIGHT NOW WITH THE TAG #SHOWYOURWORK.

- PLAN A "SHOW YOUR WORK!" NIGHT WITH COLLEAGUES OR FRIENDS. USE THIS BOOK AS A GUIDE — SHARE WORKS-IN-PROGRESS AND YOUR CURIOSITIES, TELL STORIES, AND TEACH ONE ANOTHER.

- GIVE A COPY OF THIS BOOK AWAY TO SOMEBODY WHO NEEDS TO READ IT.

"BOOKS ARE MADE
OUT OF BOOKS."

— CORMAC
McCARTHY

- BRIAN ENO, A YEAR WITH SWOLLEN APPENDICES
- STEVEN JOHNSON, WHERE GOOD IDEAS COME FROM
- DAVID BYRNE, HOW MUSIC WORKS
- MIKE MONTEIRO, DESIGN IS A JOB
- KIO STARK, DON'T GO BACK TO SCHOOL
- IAN SVENONIUS, SUPERNATURAL STRATEGIES FOR MAKING A ROCK 'N' ROLL GROUP
- SIDNEY LUMET, MAKING MOVIES
- P. T. BARNUM, THE ART OF MONEY GETTING

Y.M.M.V.

(your MILEAGE MAY VARY!)

{

SOME ADVICE CAN BE A VICE.

FEEL FREE TO TAKE WHAT YOU CAN USE,
AND LEAVE THE REST.

THERE ARE NO RULES.

I SHOW MY WORK AT:
WWW. AUSTINKLEON .COM

OUR OBITUARIES ARE WRITTEN BEFORE WE'RE DEAD.

BIG ART GETS SMALL, SMALL ART GETS BIG.

INVENT ANOTHER YOU — THEN YOU CAN BLAME HIM.

FIRST, BE USEFUL, THEN NECESSARY.

theme: what gotten you

WHAT YOU HATE — SELLING OUT — ANTI-MASTERY

THUMB YOUR NOSE — BAD TASTE — PUNK — HONEST

AMATEUR — RAW / FRESH — EXPERIMENT — CHEAP — EXCITING

CONNECTION — DE-MYSTIFY — D.I.Y.

MOUTHFUL !!! — FINDING YOUR POSSE — USEFUL — SOMEBODY SHOULD...

COMMUNICATION — don't wait for someone to come along

"I THOUGHT I WAS THE ONLY ONE."

REACTION

the spectator completes the work of art — DUCHAMP

MESSAGE — ZINES — NO PLAN — VOICE — SPEAK UP — MAKE MISTAKES

IDEAS — ALL PUB IS SELF-PUB — FANZINE — LEARN — RE-LEARN

TASTE — MAGAZINE

DOCUMENT — EXPRESSION — SELF-EDUCATION

CATALOG — experience

OWN YOUR TURF — DADAISTS

PUT ON A SHOW — POOR RICHARD

KNOWING THE NAME FOR SOMETHING

OUTLET

SKILLS
· writing
· drawing
· design

PRODUCT

PRO C ESS

the iceberg metaphor

YOU FIND YOUR VOICE BY JOINING THE CHOIR.

MAR 0 1 2013

O
ABCDEF GHIJKL

FORGET the BIG IDEA
LOTS of Little IDEAS.

"I'VE NEVER PLANNED ANYTHING. I HAVEN'T HAD ANY CAREER AT ALL. I ONLY HAVE A LIFE."
— WERNER HERZOG

A PUBLIC FILING CABINET.

HIDE + SEEK

THE BEST THING TO DO IS CLICK PUBLISH AND WALK AWAY. CLOSE THE LAPTOP AND GO BACK TO WORK. IN THE MORNING, YOU CAN RETURN, LIKE A ~~TRAPPER~~ HUNTER CHECKING HIS TRAPS, TO SEE IF ANYBODY HAS TAKEN THE BAIT.

29

THE DRAWER

HUMANS DREAM OF TIME-TRAVEL WHEN IT'S ACTUALLY AT OUR FINGER-TIPS.

A DRAWER IS A KIND OF TIME MACHINE. WHEN YOU'VE FINISHED A PIECE OF WORK, YOU DON'T KNOW RIGHT AWAY IF IT'S ANY GOOD, BECAUSE YOU'RE TOO CLOSE TO IT. YOU MUST BECOME AN EDITOR, IT'S TOO FAMILIAR. WHEN YOU'RE STILL the CREATOR.

YOU MUST, SOMEHOW ESTRANGE YOURSELF FROM WHAT YOU'VE MADE. THE EASIEST WAY TO DO THIS IS TO PUT IT AWAY AND <u>FORGET ABOUT IT.</u>

"JUST BE YOURSELF" IS TERRIFIC ADVICE IF, UNLIKE ME, YOU HAPPEN TO BE NATURALLY GIFTED AND PLEASANT TO BE AROUND.

CATCHING EYEBALLS IS EASY, BUT GRABBING ~~BRAINS~~ HEARTS IS HARD.

★ NORTH STAR

LOOK AT THE NUMBERS, BUT BE BRAVE ENOUGH TO IGNORE THEM. ~~GETTING~~ RESPONSES IT'S OKAY TO LET TO YOUR WORK ~~CAN~~ PUSH ~~YOU~~ IN IS DIFFERENT DIRECTIONS, BUT IT HELPS TO ~~HOLD~~ AN INTERNAL COMPASS, SO ALWAYS KEEP AN EYE ON YOUR YOU DON'T GET LOST IN the WOODS.

THE GULP

(SEP 2 7 2012)

THERE'S A PERIOD OF TIME, ACCORDING TO JONATHAN LETHEM. A PLACE AFTER YOU'VE FINISHED SOMETHING AND BEFORE YOU'VE PUBLISHED IT, IN WHICH IT NO LONGER BELONGS TO YOU, BUT IT DOESN'T BELONG TO THE AUDIENCE YET, EITHER. HE CALLS THIS "THE GULP." IT'S AN UNSETTLING PLACE.

WHAT IF WE GIVE IT AWAY?

EVERY LITTLE PIECE OF
yourself ONLINE IS A Potential
RABBIT HOLE FOR somebody
to STUMBLE DOWN....

HORCRUX?

→ MOST ART WE LOVE
HAS THE EXACT QUALITIES
WE'RE AFRAID OF REVEALING
IN OUR OWN WORK:
IMPERFECTION, vulner
IT'S UNPOLISHED, VULNERABLE,
potentially EMBARRASSING,
EASILY COPIED, ETC.

spent most of the year

on

the

Internet,

NO ONE CURRENTLY LIKES THIS.

YOUR DUMBEST IDEA COULD BE
THE ONE THAT TAKES OFF:

MANY OF THE MOST POPULAR THINGS
I'VE POSTED ONLINE STARTED AS
STUPID IDEAS.

THIS IS THE WHOLE THING ABOUT
THE DRAWING — SOMETIMES YOU
EDIT TOO MUCH — SOMETHING
B/C YOU'RE AFRAID OF IT PERIOD.

WILLINGNESS TO LOOK STUPID...

NOT-KNOWING IS THE ENGINE
THAT CREATIVITY RUNS ON.
SOME OF MY BEST IDEAS AT THE
BEGINNING, I LITERALLY CAN'T
TELL IF THEY'RE SLIGHT OR PROFOUND.

SEP 2 6 2012

work on a book

become tiresome

THANK YOU

To my wife, Meghan, who listened to every bad idea and read every draft. She has to live with the book just as long as I do, and it wouldn't exist without her patience, her support, and her editorial guidance.

· · · · · · · · · ·

To my agent, Ted Weinstein, who helped me conceive the idea and provided the boot in my ass to get it finished.

To my editor, Bruce Tracy, my book designer, Becky Terhune, and all the folks at Workman—we make a good team.

· · · · · · · · · ·

To all my online and offline friends who helped me along the way, including: Wendy MacNaughton, Kio Stark, Matt Thomas, Julien Devereux, Steven Tomlinson, Mike Monteiro, Hugh MacLeod, John T. Unger, Maria Popova, Seth Godin, and Lauren Cerand.

· · · · · · · · · ·

Finally, to Owen, who doesn't give a hoot about any of this.

NOTES & ILLUSTRATION CREDITS

1. You don't have to be a genius.

I took the photo of Beethoven in San Francisco outside the Academy of Arts and Science in Golden Gate Park. The bust is a copy of sculptor Henry Baerer's monument in Central Park.

"Read obituaries" is also chapter 6½ in Charles Wheelan's *10½ Things No Commencement Speaker Has Ever Said* (Norton, 2012).

2. Think process, not product.

The title of the second section comes from something Gay Talese once said in an interview: "I am a documentarian of what I do."

4. Open up your cabinet of curiosities.

The engraving is from Ferrante Imperato's *Dell'Historia Naturale di Ferrante Imperato Napolitano* (1599). It's also featured in the back of Lawrence Weschler's *Mr. Wilson's Cabinet of Wonder* (Pantheon, 1995).

The photo of the sign on the brick wall was taken in a back alley somewhere in Philadelphia. It has not been altered.

5. Tell good stories.

I read about Dan Harmon's thoughts on structure in the October 2011 issue of *Wired*, which also included an illustration of his story circle.

Kurt Vonnegut drew his story shapes in several lectures, but his best explanation of the concept can be found in *Palm Sunday* (Delacorte, 1981). He revisited the shapes later on in *A Man Without a Country* (Seven Stories, 2005).

Gustav Freytag was a German playwright and novelist who wrote about what would come to be known as "Freytag's Pyramid" in his 1876 book, *Die Technik des Dramas*.

7. Don't turn into human spam.

The "Catch & Release Only" fishing sign was photographed at Mueller Lake Park in Austin, Texas.

The last photo was taken at the Dairy Queen on Manor Road in East Austin.

9. Sell out.

The title of the first section is a paraphrase of a professor at Whitman College named Tommy Howells, whose students recorded him saying, "The Renaissance, like everything else, had to be financed." Read more of his aphorisms on Twitter: @TommyHowells.

"Please pay me" is an erasure of a parking sign in Seattle, Washington.

"My business is art" is an erasure of a parking sign in Lockhart, Texas.

I spotted the church sign outside of Knox Presbyterian Church in Toronto, Ontario.

10. Stick around.

"You gotta go away so you can come back" was something David Lynch's character said on the third season of the television show *Louie*.

"Brilliant and real and true."

–Rosanne Cash

NEW YORK TIMES
BESTSELLER

"Beautiful."
—Chris Anderson
Curator of the TED
Conference

STEAL LIKE AN ARTIST · AUSTIN KLEON (WORKMAN)

STEAL
LIKE AN
ARTIST

10 THINGS NOBODY TOLD YOU ABOUT BEING CREATIVE

AUSTIN KLEON

A manifesto for the digital age, *New York Times* bestseller *Steal Like an Artist* presents ten transformative principles for unlocking the artist in all of us. You don't have to be a genius, you just need to be yourself. Nothing is original, so embrace influence, remix and reimagine to discover your own path.

Available wherever books are sold.